W9-CHP-637

The American artist Georgia O'Keeffe had been living alone on the Ghost Ranch in New Mexico for seventeen years when photographer John Loengard, on assignment for Life magazine, visited her there in 1966. Even in that vast, windswept landscape, O'Keeffe's was an imposing presence. Adamant about her privacy and about the parts of her life she consented to have photographed, O'Keeffe, then eighty years old, proved a challenging but rewarding subject.

Striking in their simplicity and bold composition, the fifty photographs in this classic volume – arranged in sequence from sunrise to sunset – record a day in the life not of a renowned painter, but of a woman living alone in a lonely setting. Yet the pictures offer a clear connection between the austere poetry of the landscape and O'Keeffe's own self-created outer and inner worlds, her artistic imagination being filtered by the bleached bones and infinite emptiness of the desertswhich, as she said herself, "knows no kindness with all its beauty". Accompanied by some of O'Keeffe's reflections on life in the desert, and by the photographer's illuminating
recollections of the three-day shoot, this remarkable volume, reprinted in an attractive smal format, is a stunning example of the important dynamic that exists between photographer and subject, and remains one of the most stirring photographic essays ever created of an American artist.

John Loengard received his first assignment from Life while still an undergraduate at Harvard. His books include Pictures Under Discussion, which won the 1987 Ansel Adams Award for excellence in photographic books, Life Classic Photographs, Life Faces, and Celebrating the Negative. His work has appeared in Life, People (which he co-founded in 1973), the Sunday Times (London) and Travel & Leisure.

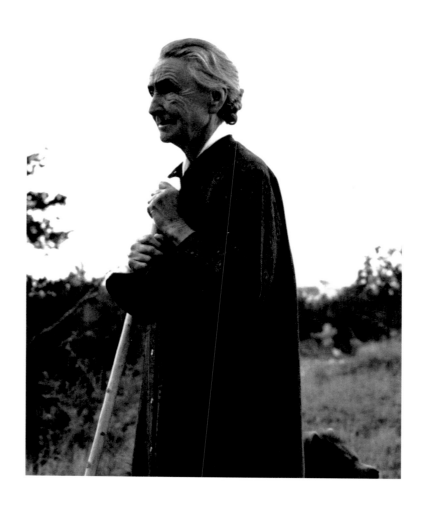

1 Morning walk, Ghost Ranch 1966

John Loengard

ГEORGIA O'KEEFFE AT GHOST RANCH

A Photo-Essay

te Neues Publishing Company
New York

A Visit with Georgia O'Keeffe

New Mexico, 1966

Georgia O'Keeffe greeted me cordially at her door in Abiquiu, New Mexico in June 1966. A retrospective of her paintings had opened in Fort Worth, Texas, that spring and was touring the country. *Life* magazine had decided to do a story on the painter and her work. They asked me to go and photograph her. O'Keeffe had a reputation of living as a hermit – suffering no fools gladly and journalists not at all. Although my visit was arranged through her representative in New York, I was wary.

'How much time will you need to take your pictures?' O'Keeffe asked.

'A couple of days,' I answered.

'*Life* is only planning a little story,' she said.

'That depends on how good the pictures are,' I told her, which was true.

'I don't know. Let's see...' she answered, and proceeded to give me a tour of the house, introduced me to her handyman, and let me follow as she drove her four-door, white Lincoln Continental to her other home at Ghost Ranch, half an hour away. There she introduced me to her cook-housekeeper, and offered me lunch.

I was looking for something unexpected. I wanted to interest her in what I was doing and set the tone for what might follow. I had kept my cameras in their bag until lunch-time. At the table O'Keeffe began to talk of killing rattlesnakes on her walks about the property and pulled out boxes filled with rattles from a sideboard.

'May I take a picture?' I asked.

'Of course,' she answered.

I photographed her hand as she moved rattles about the box with a matchstick. I figured O'Keeffe would like *Life's* readers to see she was a killer.

Certainly she did not want to be shown painting pictures. She said that would be a photographic cliché. Indeed, the reason she had let me visit when I did was that she was *not* painting. (Her most recent canvas showed clouds as she'd looked down on them from a jet plane on her way to Indonesia.) In fact, we did not talk about painting much, and we didn't talk about photography at all. If she mentioned her late husband, it was likely in a reference to household problems – like organizing the laundry – at the Stieglitz family's summer house at Lake George, New York. I was 32, and she was 79, and she seemed happy to have a young man about if we talked of anything but her work or mine. She talked a great deal, often with

amusement. O'Keeffe played the role not so much of a painter, but of a wealthy woman, interested in the arts. She paid considerable attention to the smooth management of her household.

On each of the three days I photographed her, O'Keeffe took a thirty-minute walk at dawn and another in the evening. In between she might garden at Abiquiu (she was concerned with eating fresh, natural foods). She'd answer letters, or chat with people who came by. A man stopped in whom she'd known as a boy when he lived on another part of Ghost Ranch; her housekeeper's nephew needed advice on a personal problem; O'Keeffe's sister Claudia, from Beverly Hills, came to visit.

Clearly, O'Keeffe was no hermit. My only notes contain three or four other names I am not certain belong to what visitor – and a short list of items:

– Leonard Baskin (holds book by – seated on bed in Abiquiu).
– Bread has own baked.
– Rattlesnakes rattle collection. Walking stick used to kill.
– Saws (collection of).
– Fake flower from Neiman-Marcus (in bedroom).
– File of photographs of paintings (difficulty of keeping records on all her paintings).

In truth, drawing out a subject's personality is exhausting. Doing so resembles the Scottish game of curling. Scots and Canadians play it on a rink like one for hockey, with a large granite stone and a broom. It is a strange game. You walk in front of a gliding stone, sweeping the ice with a broom. The swept ice guides the stone. I confess I've never played, but it all looks like what I feel when I photograph. I am agreeable. I don't project my personality because I don't want to photograph my subject's reflection of me – but at the same time, I have to lead – sweep the ice and make the person follow the path I've brushed. At the slightest sign of annoyance or impatience, it's sweep, sweep, sweep, and smooth it out. It can be exhausting.

I watched O'Keeffe with a passion to see how light fell on her, to see if she'd repeat a gesture, or to wait for her to move her head a bit this way or that – all the time wondering if what she was doing really made a good picture? At other times I asked O'Keeffe to pose, and she was willing to do that and was very graceful at it.

I was there to take pictures, not notes, but I remember how things went: they went very well. I enjoyed her company, and I felt she enjoyed mine. After photographing the rattlesnakes' rattles at lunch the first day, I left to take a drive around the countryside and get my bearings. I didn't want to be underfoot at Ghost Ranch when nothing was going on that I wanted to

photograph. We'd agreed that I should go back to my hotel in Santa Fe, some 75 miles away, and come back at dawn to photograph her morning walk.

Next morning, after the walk, we went over to Abiquiu where she showed me files she used to keep track of the whereabouts of all her paintings. We visited a friend of hers, a Dominican monk who was building a chapel in Chams, but I found no pictures there. We returned to Ghost Ranch, where she wrote letters. Her sister arrived and I left.

O'Keeffe had an errand to do at Abiquiu the next morning, so that's where I met her. She showed me her collection of rocks, bragging that she'd stolen her favorite stone from Eliot Porter, the photographer. She gardened, and I made portraits of her in her bedroom. In the afternoon, we went back to Ghost Ranch, where I photographed her evening walk.

On my last day I drove out to Abiquiu to say goodbye. O'Keeffe was with the director of a museum that would be the next to exhibit her retrospective, but she was not eager to have me do more than look in. I did so and left.

A layout of my photographs wasn't done for 15 months after I returned to New York. (*Life* sometimes worked very slowly.) When it was finished, at the end of October 1967, Dorothy Seiberling, the magazine's art editor, and I went out to New Mexico so Seiberling could get quotes, and so I might take a picture for the magazine's cover.

I was happy to see O'Keeffe again, but the roof at Ghost Ranch was the only place I could think of to photograph her that I hadn't used before. As she sat before a chimney and talked to Seiberling, I took some pictures. I felt they were good. I also felt the curling game had ended, and I'd won.

<div align="right">John Loengard, 1994</div>

Plates

'When I came to New Mexico in the summer of 1929, I was so crazy about the country that I thought, how can I take part of it with me to work on? There was nothing to see in the land in the way of a flower. There were just dry white bones. So I picked them up. People were pretty annoyed having their cars filled with those bones. But I took back a barrel of bones to New York. They were my symbols of the desert, but nothing more. I haven't sense enough to think of any other symbolism. The skulls were there and I could say something with them. . . . To me they are as beautiful as anything I know. To me they are strangely more living than the animals walking around — hair, eyes and all, with their tails switching. The bones seem to cut sharply to the centre of something that is keenly alive on the desert even though it is vast and empty and untouchable — and knows no kindness with all its beauty.'

Georgia O'Keeffe

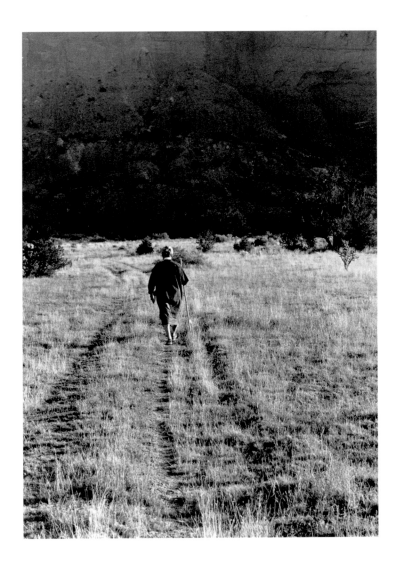

2 Morning walk, Ghost Ranch 1966

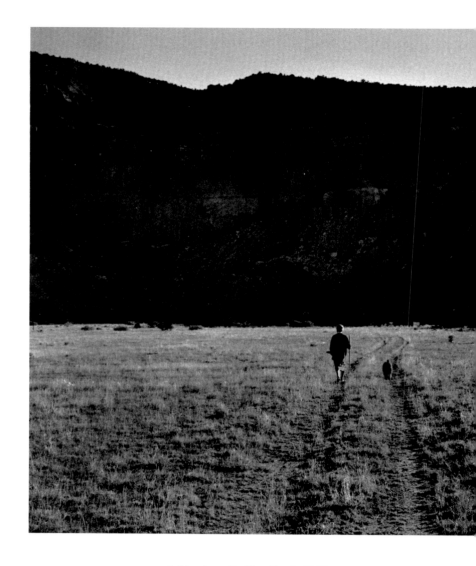

3 Morning walk, Ghost Ranch 1966

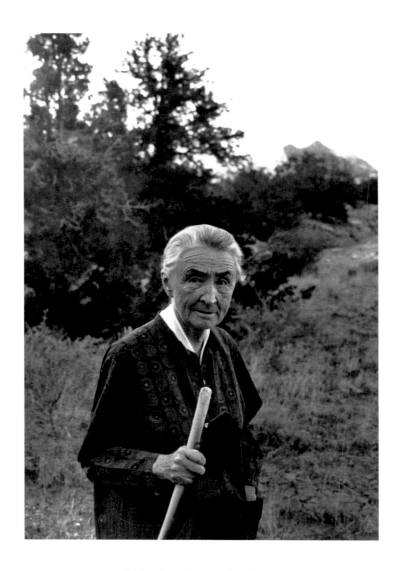

4 Morning walk, Ghost Ranch 1966

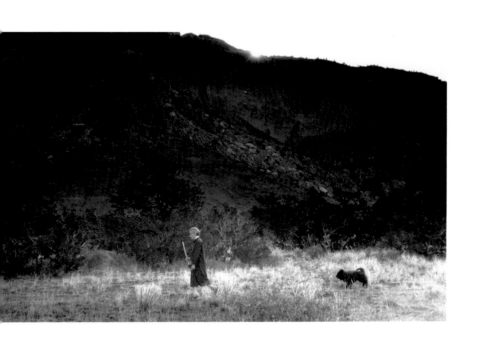

5 Morning walk, Ghost Ranch 1966

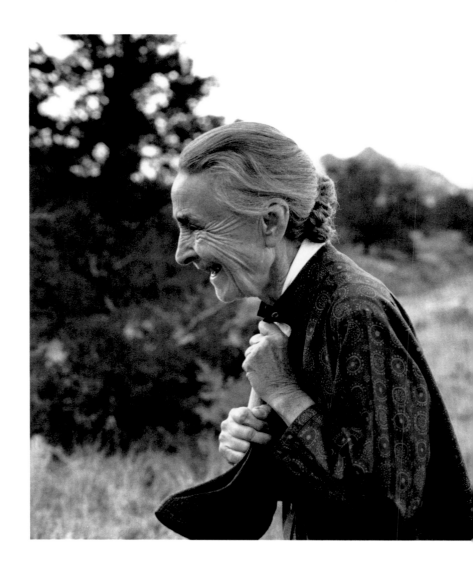

6 Morning walk, Ghost Ranch 1966

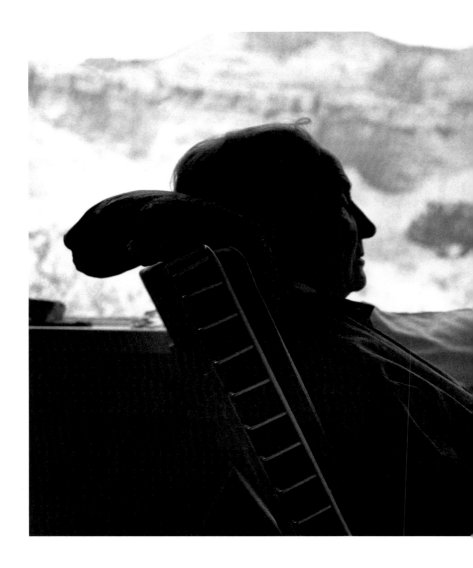

7 Reading letters, Ghost Ranch 1966

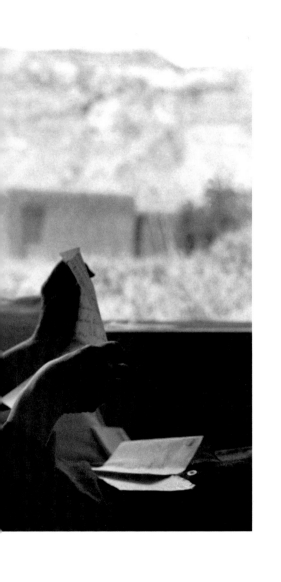

8 Ghost Ranch 1966

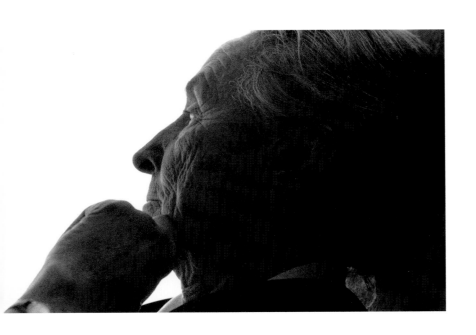

9 Ghost Ranch 1966

'I'm a newcomer to Abiquiu, that's one of the lower forms of life. The Spanish people have been here since the 18th century. The house was a pigpen when I got it in 1946. The roof was falling in, the doors were falling off. But it had a beautiful view. I wanted to make it my house, but I'll tell you the dirt resists you. It is very hard to make the earth your own. The ranch is really home to me. I've done much less to try to make it mine. All my association with it is a kind of freedom. Yet it's hard to live at the ranch. When I first came here, I had to go 70 miles on a dirt road to get supplies. Nobody would go by in two weeks. I thought the ranch would be good for me because nothing can grow here and I wouldn't be able to use up my time gardening. But I got tired of canned vegetables so now I grow everything I need for the year at Abiquiu. I like to get up when the dawn comes. The dogs start talking to me and I like to make a fire and maybe some tea and then sit in bed and watch the sun come up. The morning is the best time, there are no people around. My pleasant disposition likes the world with nobody in it.'

Georgia O'Keeffe

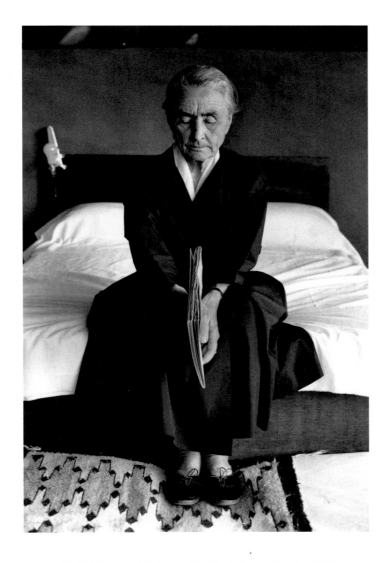

10 Holding a book by Leonard Baskin, bedroom, Abiquiu 1966

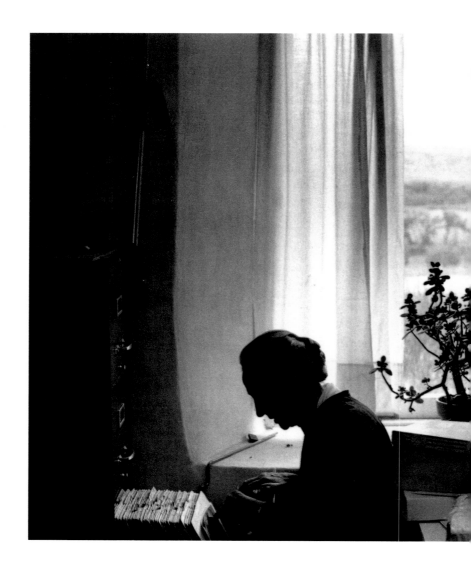

11 Working on the files, Abiquiu 1966

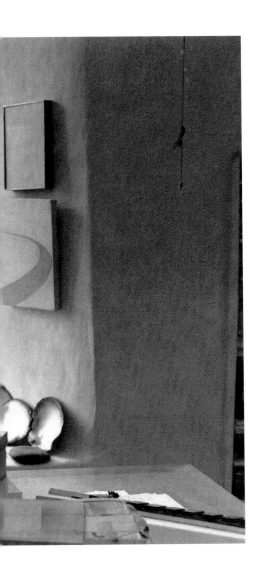

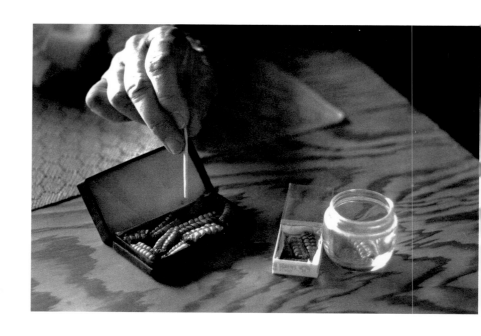

12 Rattlesnake rattles, Ghost Ranch 1966

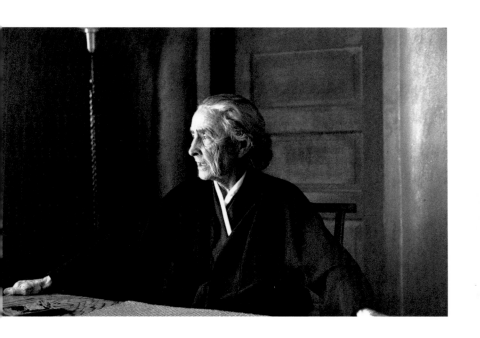

13 At the dining-room table, Ghost Ranch 1967

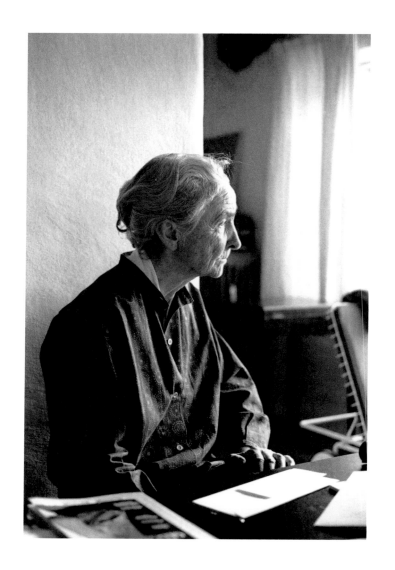

14 Writing letters, Ghost Ranch 1966

15 Ghost Ranch 1967

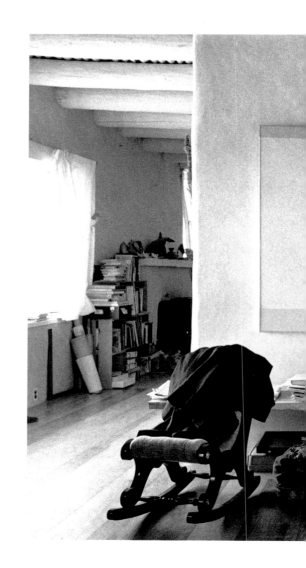

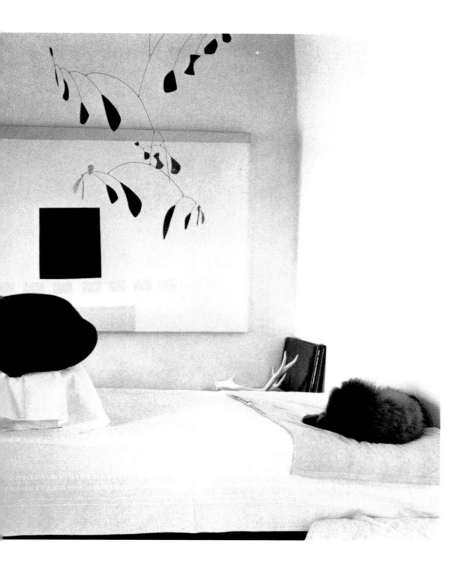

16 Bedroom, Ghost Ranch 1967

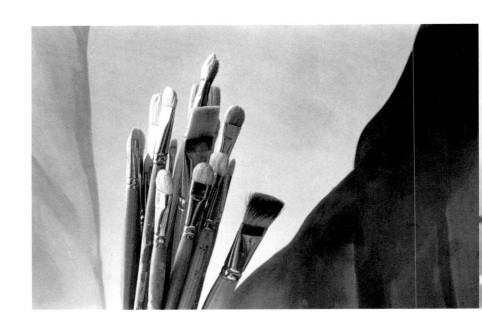

17 Studio, Ghost Ranch 1967

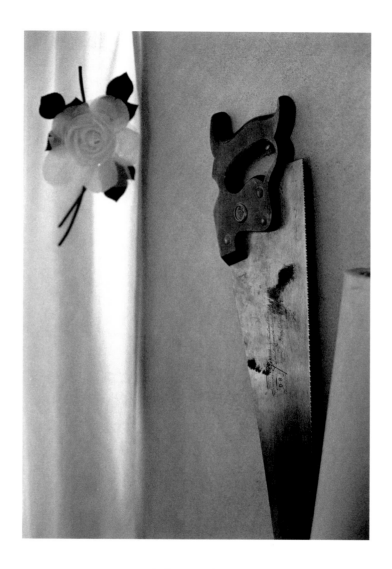

18 Ghost Ranch 1966

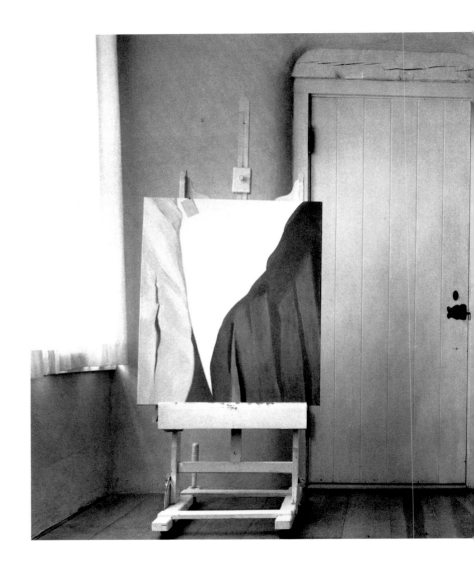

19 Sudio, Ghost Ranch 1967

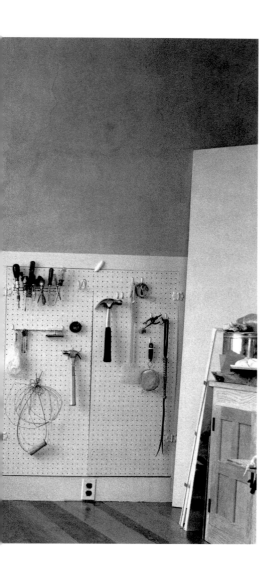

20 Ghost Ranch 1966

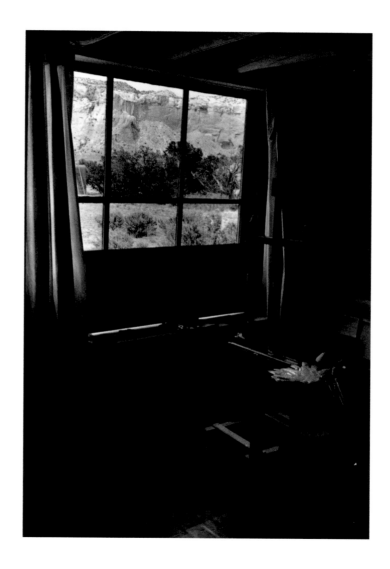

21 Studio, Ghost Ranch 1966

'For years in the country the pelvis bones lay about ... always underfoot — seen and not seen as such things can be. ... I do not remenber picking up the first one but I remember ... knowing I would one day be painting them. ... When I started painting the pelvis bones I was most interested in the holes in the bones — what I saw through them — particularly the blue from holding them up in the sun against the sky as one is apt to do when one seems to have more sky than earth in one's world. ... I have no yen to go anywhere. But I go around the world anyway to see what's there — and to see if I'm in the right place. Flying to Japan, the first thing I saw was a field of snow that you could walk on, then a sky paved with clouds. ... Wherever I go, I have an eye out for rocks. Outside my hotel in Phnom Penh I picked up a stone and carried it back around the world in my purse. ... Stones, bones, clouds — experience gives me shapes — but sometimes the shapes I paint end up having no resemblance to the actual experience.'

Georgia O'Keeffe

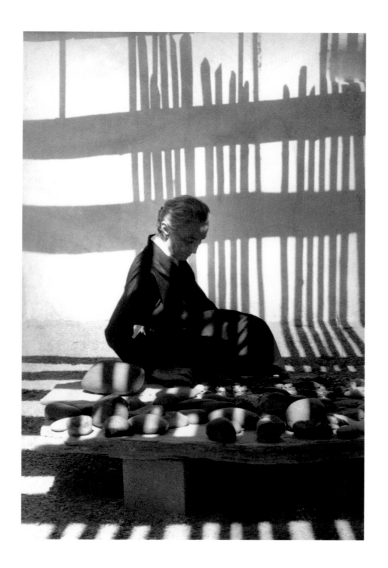

22 With rock collection, Abiquiu 1966

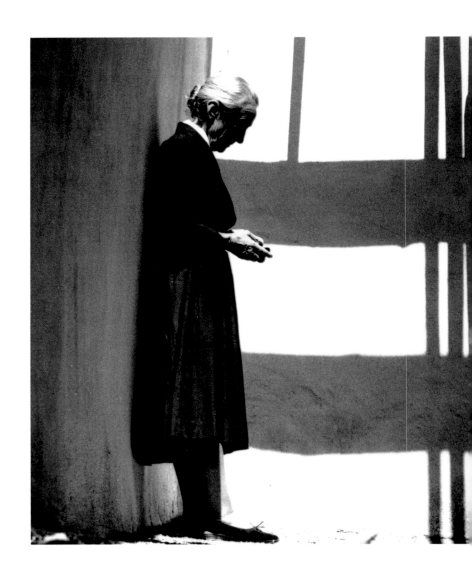

23 Abiquiu 1966

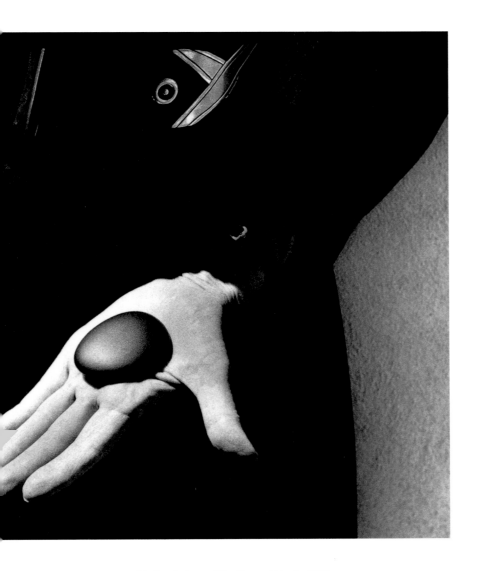

24 Der Stein von Eliot Porter, Abiquiu 1966

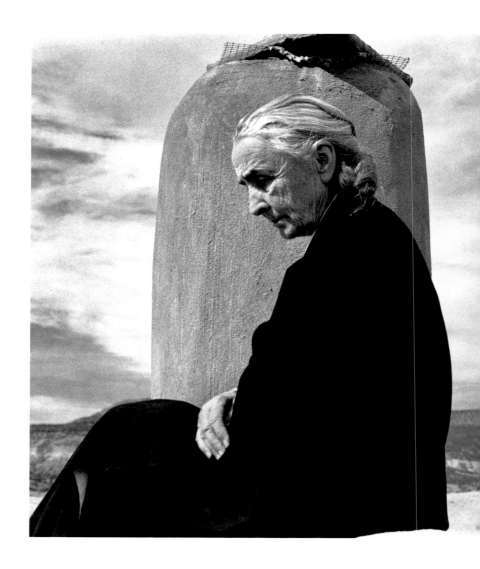

25 On the roof, Ghost Ranch 1967

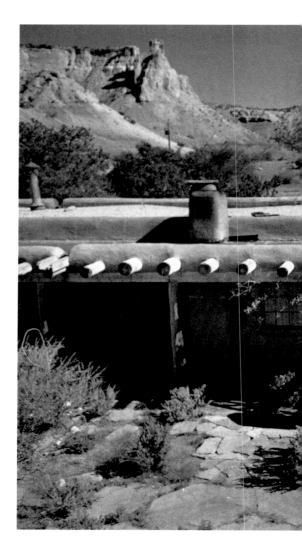

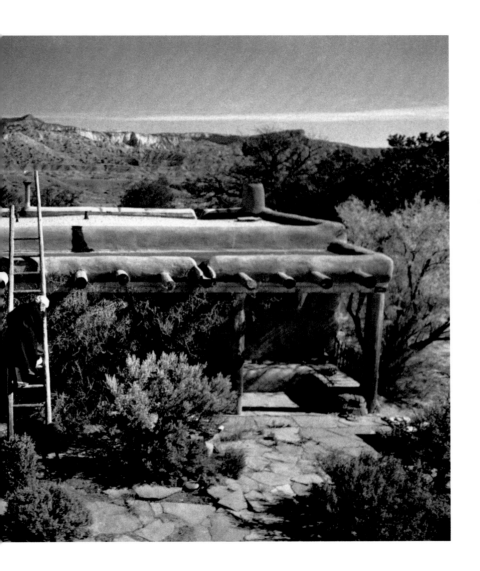

26 Ghost Ranch 1967

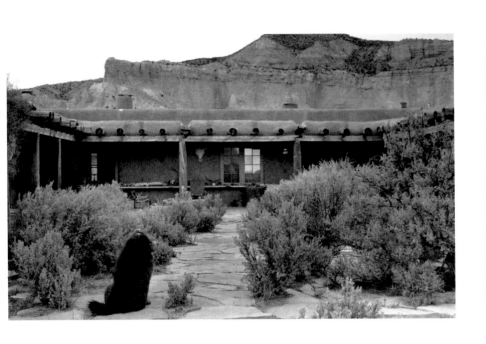

27 Ghost Ranch 1967

28 Courtyard, Ghost Ranch 1967

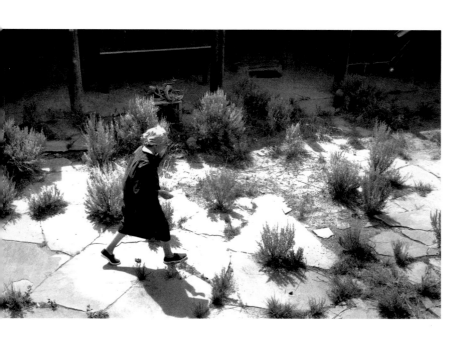

29 Courtyard, Ghost Ranch 1967

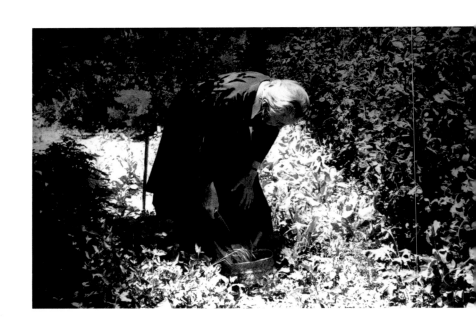

30 Gardening, Abiquiu 1966

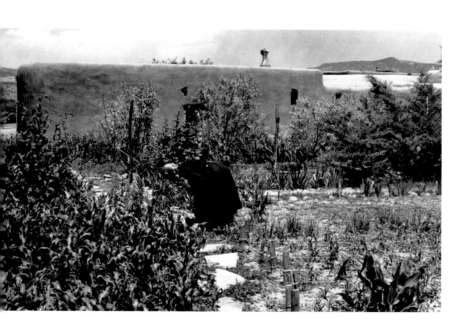

31 Gardening, Abiquiu 1966

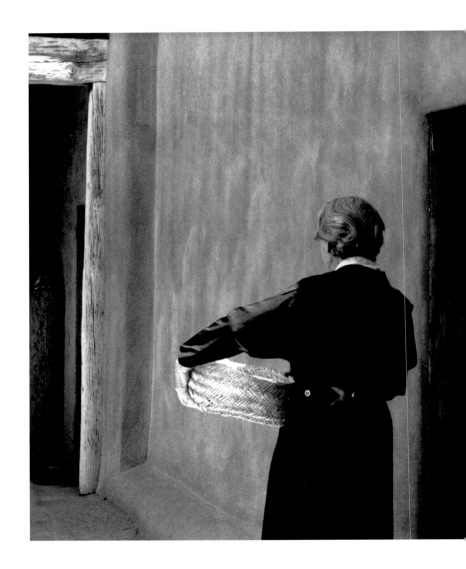

32 Abiquiu 1966

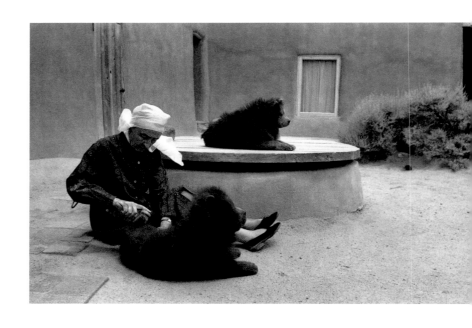

33 Grooming dogs, Abiquiu 1966

34 Abiquiu 1966

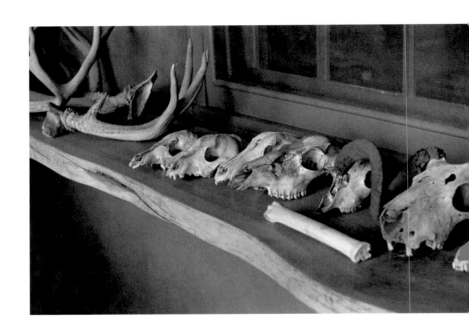

35 Ghosr Ranch 1966

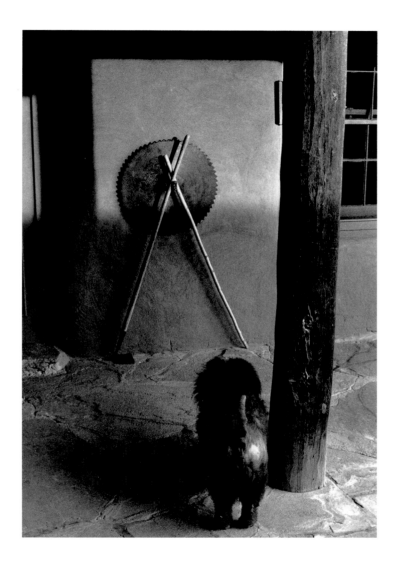

36 Ghost Ranch 1966

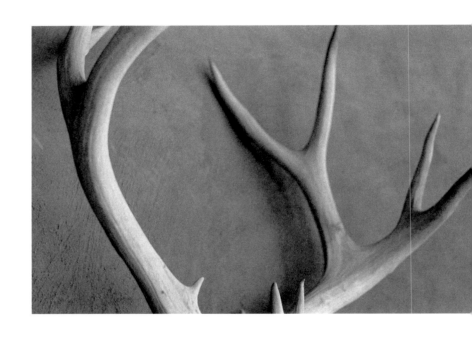

37 Ghost Ranch 1966

38 Ghost Ranch 1967

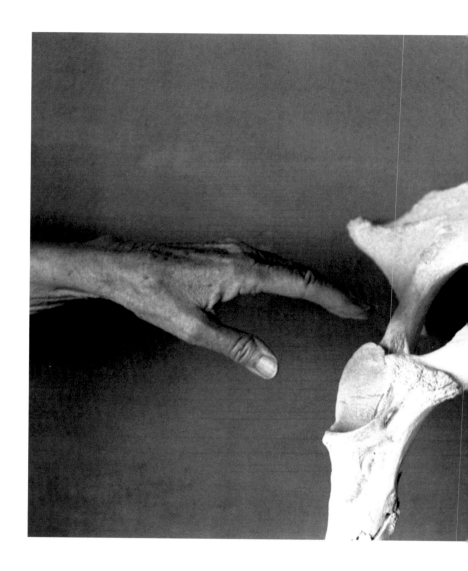

39 Ghost Ranch 1966

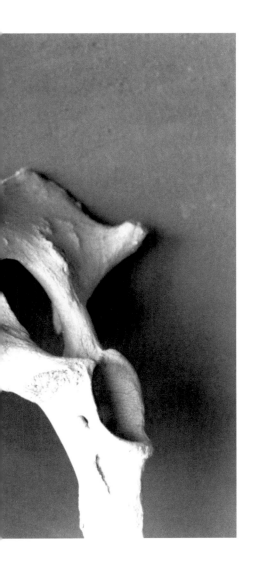

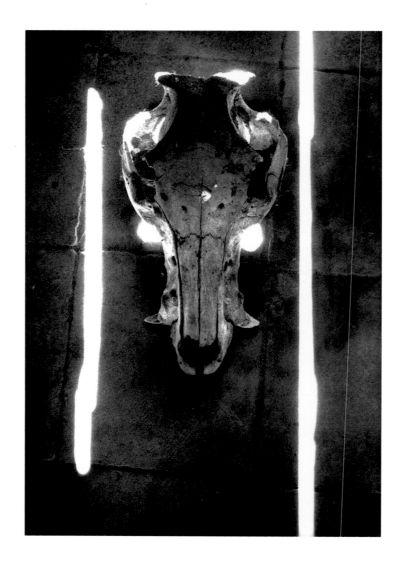

40 Pig skull, Abiquiu 1966

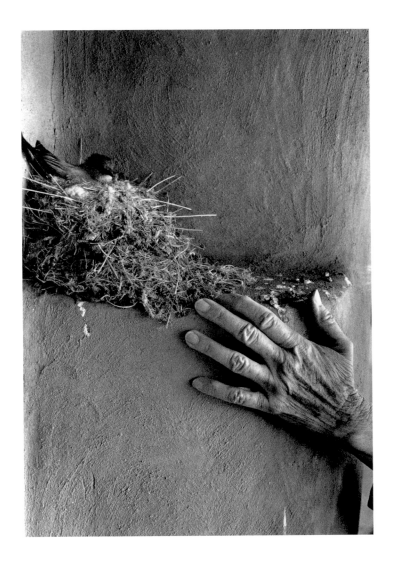

41 Ghost Ranch 1966

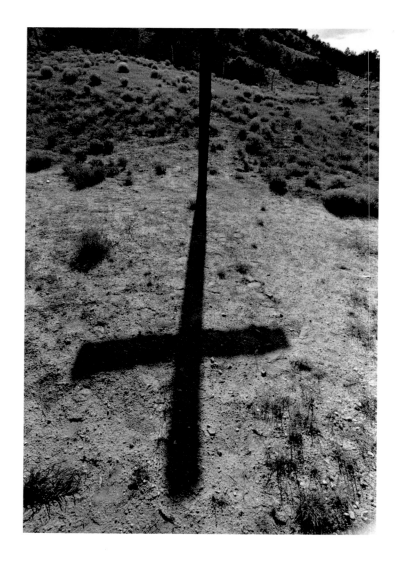

42 Penitente cross 1966

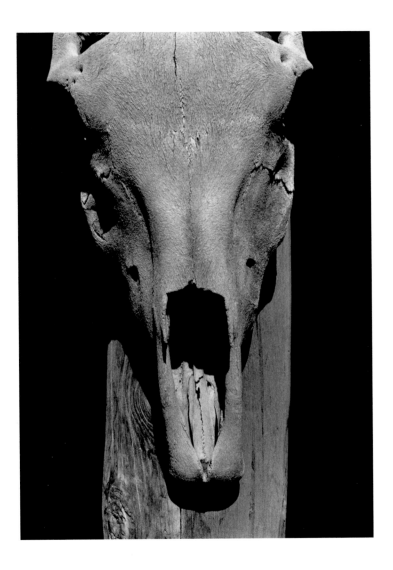

43 Cow skull 1966

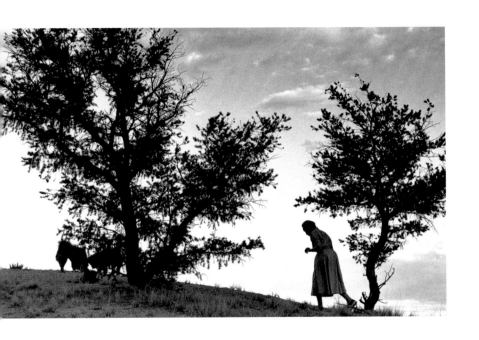

44 Evening walk, Ghost Ranch 1966

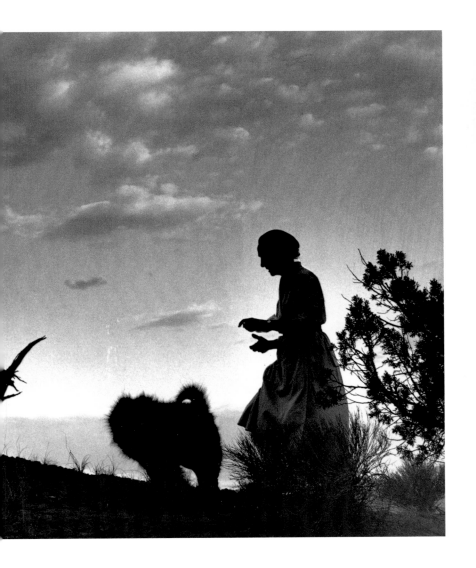

45 Evening walk, Ghost Ranch 1966

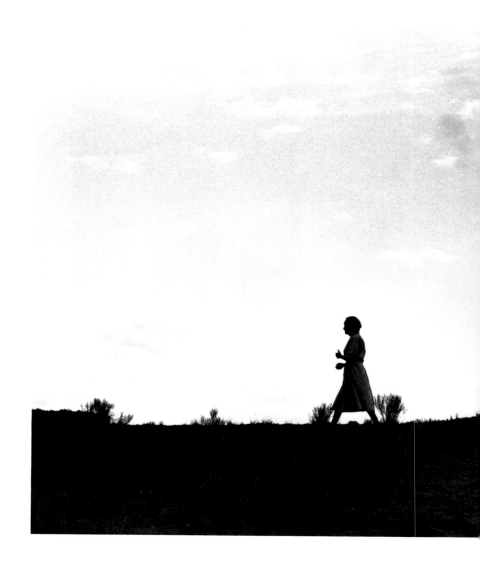

46 Evening walk, Ghost Ranch 1966

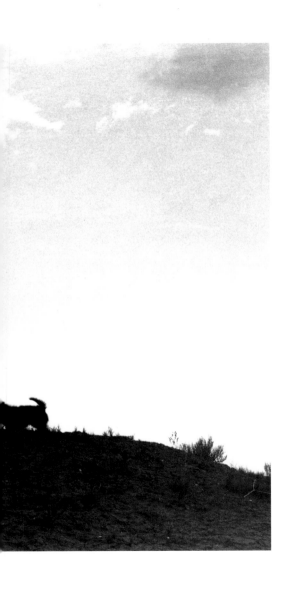

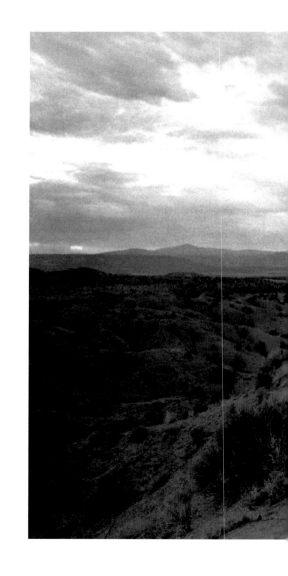

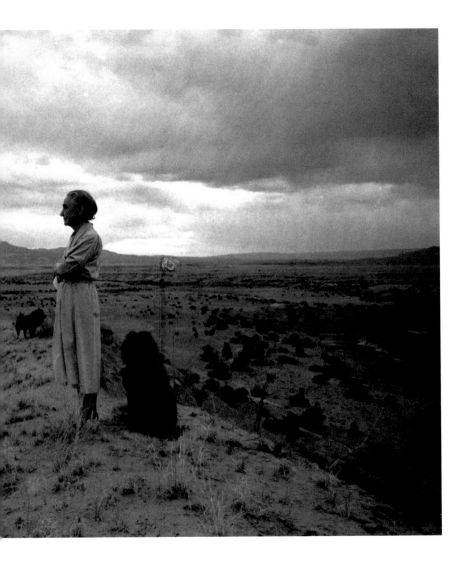

47 Evening walk, Ghost Ranch 1966

'I think more about tomorrow than today or yesterday. I'm not a regretter. I suppose I could live in a jail as long as I had a little patch of blue sky to look at. But this is my kind of world. The kind of things one sees in cities ... well, you know, it's better to look out the window at the sage.'

Georgia O'Keeffe

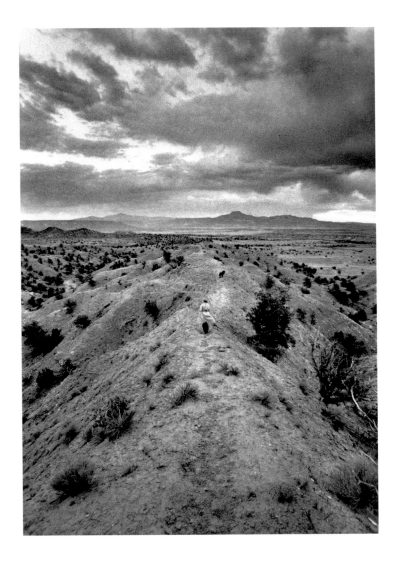

48 Evening walk, Ghost Ranch 1966

Georgia O'Keeffe

Georgia O'Keeffe was born on November 15th, 1887, the second child of a farming couple, near Sun Prairie, Wisconsin. In 1905, she began her studies at the Art Institute of Chicago, continuing in New York from 1907 at the Art Students' League. In New York, she visited Alfred Stieglitz's '291' gallery for the first time. Stieglitz was already a famous photographer, and in his gallery he supported European and American avant-garde art.

Periods of illness, and the need to earn a living, prevented Georgia O'Keeffe from pursuing her studies systematically. She worked as a commercial artist in Chicago, and taught at universities and colleges in Virginia, South Carolina, and Texas; but she kept in touch with the '291' gallery throughout this period. In 1917, Stieglitz showed her first one-person exhibition — with charcoal drawings and water-colors — and began his large-scale photographic project of producing a 'total portrait' of Georgia O'Keeffe, which he continued until 1937. It ultimately included over 300 shots.

Thanks to financial support from Stieglitz, Georgia O'Keeffe was able to devote herself entirely to her painting from 1918 onwards. She moved to New York, where Stieglitz put on her first large exhibition, with 100 paintings, at the Anderson Galleries in 1923. They married in 1924. From then on, she regularly exhibited her current work in Stieglitz's various galleries, at the Intimate Gallery (1925–1930) and 'An American Place' (1930–1950). During the 1930s, her name became familiar well beyond the circle of artists around Stieglitz. She met with increasing public and official recognition, receiving many prizes and honorary degrees. In 1934, the Metropolitan Museum purchased its first painting by her; in 1943, the Art Institute of Chicago held its first exhibition of her work; and in 1946, the Museum of Modern Art organized a large-scale retrospective, its first one-person exhibition devoted to a woman.

The New Mexico landscape had fascinated Georgia O'Keeffe ever since her first visit in 1917. From 1929 on, she spent the summer in New Mexico every year, from 1934 at Ghost Ranch, where she bought a house and some land in 1940. Five years later, she also purchased a ruined adobe house in the neighboring village of Abiquiu, and put in sev-eral years of renovation work to make it inhabitable. After Alfred Stieglitz's death in 1946 and the settlement of his estate, she moved to New Mexico permanently, living and working there for nearly four more decades — with breaks for trips that she made all over the world.

She died in Santa Fe in 1986, shortly before her ninety-ninth birthday.

John Loengard

John Loengard was born in New York City in 1934. He received his first assignment from *Life* in 1956, while still an undergraduate at Harvard, and joined the magazine's staff in 1961. During the 1960s, *American Photographer* hailed him as '*Life's* most influential photographer'. Many of the pictures he took during that period, including his photographic essays 'The Shakers' and 'Georgia O'Keeffe', are now considered classics of their genre.

In 1973, Loengard was appointed picture editor of the ten semi-annual *Life Special Reports*, after the magazine ceased weekly publication in 1972. He was instrumental in the rebirth of *Life* as a monthly in 1978, and served as its picture editor until 1987. He is still one of the magazine's contributing photographers. It was under his direction that *Life* won the first award for 'Excellence in Photography' ever made by the American Society of Magazine Editors, in 1986.

Pictures Under Discussion, a book of his own photographs, won the Ansel Adams Award for excellence in photographic books in 1987. Further publications of his work in book form followed: *Life Classic Photographs* (1988), *Life Faces* (1991), and his homage to the photographic negative, *Celebrating the Negative* (1994).

Loengard's freelance work appears in *Life*, *People*, the *Sunday Times* (London) and *Travel & Leisure*. Photographs by Loengard are in the collections of the International Center of Photography, the International Museum of Photography at George Eastman House, the Vassar College Art Gallery, and the Menil Foundation. His work is represented by the *Life* Gallery of Photography and the James Danziger Gallery, New York.

John Loengard took the photographs in the present volume on assignment from *Life* in June 1966 and October 1967. His photographic essay was published as the cover story of the March 1st, 1968 issue of *Life*, under the title 'Georgia O'Keeffe — Stark Visions of a Pioneer Painter', with an introduction by Dorothy Seiberling.

Published in the U.S.A. and Canada
by te Neues Publishing Company, New York

Photographs © 1994 by John Loengard
© of this edition by Schirmer/Mosel, Munich 1998

Lithography by Nova Concept, Berlin
Typeset by Typograph, Munich
Printed and bound by EBS, Verona

ISBN 3-8238-9965-1
A Schirmer/Mosel Book